SECRETS OF TATTOOING
A GUIDE TO REDISCOVERY

A GUIDE TO REDISCOVERY

©Erick Alayøn 2007
www.erocktattoo.com

Registered with the United States Library of Congress

All rights reserved. No part of this Publication may be reproduced in whole or in part, in any way or by any means, Electronic, mechanical, photocopying or Otherwise, without the prior written Permission of the copyright holder.

The author has made every effort to ensure that all the information contained in this book is accurate. The author cannot accept liability for any resulting injury, damage or loss to persons or property as a result of using any of the information contained herein. Before you begin a Tattooing project, you should know how to use all of your tools and equipment safely and that you are sure and confident about what you are doing.

"**Liberty is meaningless where the right to utter one's thoughts and opinions has ceased to exist. That, of all rights, is the dread of tyrants.**"
Frederick Douglass

"**To limit the press is to insult a nation; to prohibit reading of certain books is to declare the inhabitants to be either fools or slaves.**"
Claude Adrien Helvetius

"**To choose a good book, look in the Inquisitor's prohibited list.**"
John Aikin

**For my wife
Meaghen**

Introduction	11
Frame Geometry	13
Cut Back Machine	19
Coil Position	21
Swing Arc	23
Angle of Deflection	27
Breaking the Rules	29
Springs	31
Rear springs	31
Front Springs	35
Making Springs	38
Contact Screws	41
Coils and Capacitors	43
Coils	43
Capacitors	44
Tattoo Needles	47
Adjusting Machines	53
Machine Frames	57
Boiling Down Black	63
Shading	65
Gray Wash	65
Sumi	66
Mixing Ink	69
Tattoo Pigments	73
Spit Shading Flash	77
Other "Secrets"	81
Tattooing	81
Stencil Applying	82
Soaps	83
Water Dipping Rinse	83
Spitting Machines	84
Frame Hardware	85

Tube Bath .. 86
 Beveled Tube Tip ... 87
 Changing Colors... 87
 Lining with a Shader Tube 88
 Rubber Bands .. 89
 Back of the Neck Tattooing 89
 Soldering... 89

Conversion Charts 91
 Fraction/Decimal .. 91
 Gauge/Decimal .. 92
 AWG/Inch/MM .. 93
 Inch/CM-CM/Inch .. 94
 Tap Drill Chart .. 95

Recommended Reading 97
Words of wisdom 99
Index ... 101

Introduction

With all the books I've written about tattooing I try to bring up information that has not been touched upon elsewhere. Where I feel the information in my other two books succeed at this, this one is a bit different. Most of the information in this book has never been published before. I would like to say all of it but I can't be totally sure, but if we had a wager going I would feel comfortable with the bet. The reason I write these books is because I know how hard it is for young people to break into Tattooing. Tattoo Artist's guard this art like it's some kind of top-secret knowledge. In fact a lot of "secrets" have been kept so secret that they're forgotten! Just look at all the Machine discussions on the Internet, a lot of intelligent Tattoo Artists are figuring out for themselves what should have been handed down to them. It's good that this information is being rediscovered, and also shared by a few people that have had this information passed down to them. Unfortunately, there are a few who learn these "secrets" from other people and yet they feel the need to jealously guard them, as if it's their own exclusive information. Well, it's not, it's here to be shared and I'm here to share it. I don't care if someone knows more than me, or if I share this information with you and you become a better Tattoo Artist than me. That doesn't matter, in fact that is my goal, to make you a great Tattoo Artist. I want my books to inspire you and help make

your journey easier. But it's not an easy journey. It's a "Hero's Journey" and you will be following the path of Joseph Campbell's "Hero with a Thousand Faces". All the elements of the Heroic Journey are there, Allies, Mentors, Shape Shifters, and Threshold Guardians. It's a good thing you have my books to guide you and help you return with the Elixir! But in reality, there is no Elixir, there is no ultimate secret for you to find, and return with, that will make you the greatest Tattoo Artist that has ever lived. This journey is a constant journey of discovery, the only reward is your love of the journey and the excitement of the journey itself, but that's enough of a reward.

Well, I wish you luck on your journey, and if your journey ever crosses with mine, stop, for a moment, and say "Hello!"

<div style="text-align: right;">
Erick Alayon
February 2007
</div>

Frame Geometry

Frame Geometry is not as complicated as you might think, it's only as complicated as you make it. Basically it's where the Spring Shelf, Front Binding Post and Tube Vise are in relation to each other. These three things decide the speed and throw a Machine has. Changing one of these variables changes the way a Machine will run. Rear Spring Tension, Rear Spring Thickness, Coils etc. will also

Machine Anatomy

affect how a machine runs, but the Geometry is the major difference and is what we are concerned with at the moment. A Machine will have either Long Frame Geometry or Short

Frame Geometry. The main difference between the two is the measurement from the front of the spring saddle to the center of the tube vise. The example of a Long Frame is a Sailor Jerry Bulldog, the short frame example is a Paul Rodgers repro. The long frame has a measurement of 2- 1/8' and the short frame has a measurement of 1- 7/8". If you're not familiar with Machine Anatomy please refer to the picture of Machine Anatomy. These measurements can vary, I would consider any measurement of 2" or more a Long Frame, and measurements under 2" a Short Frame.

Long Frame Geometry

Short Frame Geometry

How does Frame Geometry affect the way a Machine runs? There are many variables that can affect the way a Machine runs, but the one we're going to talk about here is where the Point Gap, or Spring Gap, is in relation to the Armature Pin. Spring gap, or Point Gap is the distance between the contact screw and front spring when the Armature is touching the front coil.

The Spring shelf acts as a fulcrum for the Armature set-up. If you look at a Machine you will notice that the rear spring and Armature Bar are in a straight line. The Front spring jets out at a different angle. This is what makes frame geometry work. You can run a machine

without a front spring. (I said you could **run** a Machine without the front spring, not **tattoo** with it.) If you remove the front spring and adjust the contact screw all the way down to the Armature bar, you'll see it works. Try it, it runs like shit, but it runs. What the front spring does is decide what kind of Throw the Machine will have. Throw is the distance the Armature Pin moves during its up and down cycle. By moving the position of the Spring gap back the Throw will be much greater than the Spring Gap. By moving it forward it would start to even out. If we move the Spring gap past the Armature Pin, the Spring gap will be greater than the Throw.

The best way to demonstrate this is with a Cut Back Machine.

Cut Back Machine

Cut Back Geometry

The Picture above is a Micro Dial Machine. This Machine is great for this example as it has Long Frame Geometry and a "Cut Back" front Binding Post. This gives us both extremes. You will notice the Front Binding post is pulled back roughly ¼" as compared to the other two frames we looked at. Some Cut Backs are pulled back even further. You will notice that this geometry requires a shorter Front Spring. If we put a regular spring on this set up it would defeat the purpose of having a Cut Back frame. With the Machine set up like this we could tune it with a small Spring Gap,

which would make a fast running Machine. Being that the Spring Gap is much further back from the Armature Pin the Throw will be much greater. How much greater? Lets take a look...

Cut Back Throw

The small dot shows the size of the Spring Gap, the large dot represents the distance of the Throw. See the difference! This Machine set up this way will run fast with a Long Throw. A lot of Artist use this set up for outlining.

Coil Position

The coils should be positioned as far forward on the frame as you can get them. As long as the front coil does not interfere with the tube vise. There should be very little space between the coils when they are both positioned on the Machine. If you look at the Machines throughout this book you will see the coils set all the way forward. The holes drilled for the Coils must also be in line with the Rear Spring hole and the Tube Vise.

The Coil holes must be inline with the Rear Spring hole and Tube Vise.

Swing Arc

Swing Arc

The picture above illustrates the Swing Arc. This is the radius that the Armature Bar moves. The Fulcrum Point is the point where the Rear Spring Pivots up and down. If we were able to swing the Armature Set up around its fulcrum point it would make a complete circle. The Spring Gap moves on its own arc. As you can see, in this case, the Arc of the Spring Gap will make a smaller circle. The movement shown in the picture here is very exaggerated. If we were to move the Spring Gap forward so it falls on the Arm-pin's Swing Arc, the Spring gap and the Throw would be the same. In

reality Rear Spring tension would make the throw slightly greater but, for the sake of argument, if the tension were just enough to make connection with the Contact Screw they would be the same distance. If we move the Spring Gap past the Arm-pin's Swing Arc then the Spring Gap would be greater than the Throw.

With the Spring Gap pulled back the Machine will run fast. The further forward you move the Spring gap in relation to the arm-pin's Swing Arc, the slower the machine will run. This is true as long as you keep the distance the Armature pin moves the same, meaning you have to adjust the Spring gap greater as you move it forward. If you keep the gap the same it will run as fast but the throw will diminish. To keep it simple, if the spring gap were dead even with the swing arc of the Arm-pin you would have to increase the Spring gap to get the Throw you need to use the Machine. If you keep the gap small in this situation, the throw would be small and therefore the needles will not penetrate the skin deep enough.

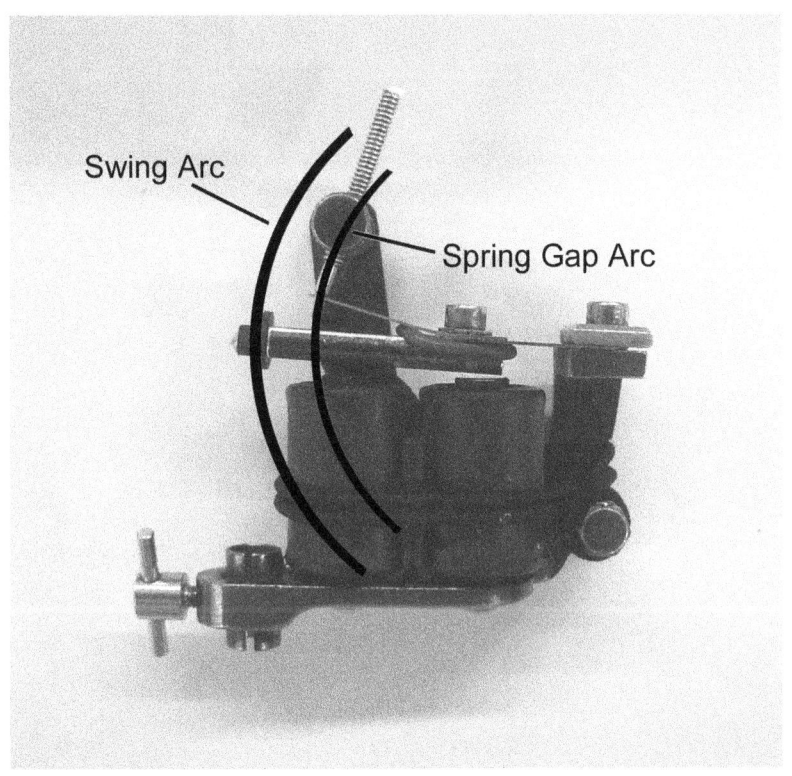

This picture better illustrates the different radius of the Spring Gap as compared to the Swing Arc.

Angle of Deflection

The Angle of Deflection describes the Angle of the Spring Shelf as compared to the Coil Shelf. The Spring Shelf can be parallel with the coil shelf or can be set on a very slight angle, usually not more than 3 degrees. The angle, if any, should go down toward the rear of the Machine. Weather or not the Spring Shelf is angled depends on the individual builder of the Machine.

Breaking the Rules

The picture above is of a friends Machine. It's a Cut Back Frame with a replaceable Tube Vise, the old one broke. The measurement from the front of the Spring Shelf is to the center of the tube vise is roughly 2- 3/16". This machine definitely has a Long Frame Geometry. If you look at the picture you will notice that although this is a Cut Back Frame, it's not set up as one. What my friend did was change the shorter Front Spring with a regular one. Then he adjusted the contact screw so the Spring

Gap is more forward. It's set back just a little from the Swing Arc so the Throw will be just a little greater than the Gap. This Machine runs great! And the owner of it is an excellent Tattoo Artist.

Springs

Rear springs

A Machine with a weak rear spring will run faster than a Machine with a strong rear spring. The thicker the rear spring the stronger it will be in comparison to a thin one. Spring thickness is usually measured by gauge. The most common sizes are 16, 18 and 20 gauge.

Rear Springs also come in different widths. The wider the rear spring the stronger it will be. If you have a wide spring you can thin it out with a pair of snips. I have read where

some people suggest that you can grind a spring against a sanding belt of with a motor tool. NEVER DO THIS. The heat generated by these tools will ruin the spring's temper and anneal it. When a spring is annealed it is no longer a spring. Use a good pair of snips or shears and make the cut in one continuous motion. Stopping in the middle a cut can leave imperfections that will make the spring crack under stress. After you cut the spring you can smooth edge with a small file or fine emery cloth. Any deep scratch or especially a nick on the edge of the spring will cause a stress crack.

Rear spring tension can be adjusted to fine-tune your Machine further. To adjust rear spring tension loosen the saddle screw and swing the Armature set up out to a 90-degree angle. If you need more tension press the Armature bar up, bending the spring a little. Remember a little goes a long way. Put the Arm set up back where it belongs and tighten the screw. Run the machine and make further adjustments if need be. The more tension the rear spring has the slower it will run.

Rear spring tension is also affected by the machines working length. This is the measurement of the rear spring from the front of the Spring shelf to the rear of the Armature bar. The shorter the distance the stiffer the spring will be. You can adjust this distance somewhat by sliding the rear spring forward or backward a little, but if you do this you will

have to readjust your armature bar so it realigns with the tube vise. There is usually not very much room for adjustment here on most Machines. Another way to increase the Working Length is to file 45-degree cut from the front of the spring shelf. But this is a permanent alteration to your frame so make sure that's what you want and you know what you are doing.

This picture illustrates what the Shelf cut should look like. But remember this is a permanent alteration to your Machine. This alteration will increase the Rear springs Working Length that will weaken the rear spring. Remember, I'm not *telling* you *to* do

this alteration. This should only be done by a competent Tattoo Artist who knows what will be achieved by doing this alteration. You must also be fully competent in the use of the tools needed to perform this alteration.

Front Springs

The most common sizes for Front Springs are again 16, 18 and 20 gauge. Front springs come in two basic shapes. A triangle shape and an upside down "T" shape. I personally hate the "T" shape. Not only does it look stupid but it's also weaker than the triangle ones because it does not widen at the bottom.

Take your Machine and slowly pull your Armature bar down, keep your eye on where the front spring meets the Contact Screw. You will notice that the front spring relaxes a little as you pull down on the Armature bar. Slowly let the bar back up and you will see the spring make contact with Contact screw and flex a little before it comes to a rest. How much the front spring gives depends on the tension of the rear spring. It also depends on how stiff or strong

Triangle Front Spring

"T" Shape Front Spring

35

the front spring is. A weaker front spring will, of course, flex more than a stronger one. The stronger the front spring the faster the Machine will be. However, you don't want the Front spring to be so stiff that it doesn't not flex at all. The Machine will run to clanky. The flexing action of the Front spring acts as a shock absorber.

The Front spring is angled up from the Armature bar to meet with the Contact screw. This angle isn't really too important. Around 25 degrees up from the Arm bar is about the average. One of my Machines has the angle about 15 degrees. I wouldn't go any lower than that.

Spring Shelf Riser

You can raise the spring higher on the Spring Shelf with a spring riser. The riser can be made from any material like brass, copper or steel. Cut a piece of from some stock that is the thickness you need and make it the same size as the spring shelf. Drill the hole for the screw and that's it.

Making Springs

When you cut the spring material you have to use a good pair of snips or sheet metal cutting shears. Sheet metal shears will work the best. Don't use electric grinders or sanders. The heat generated can ruin the temper of the metal and once a spring's temper is ruined it looses its resilience, meaning it will just bend without springing back.

Use a spring punch to punch out circles and snip the metal away for the "U" shapes. If you have to smooth things out use a file or emery cloth. Make sure there are nicks or small scratches on the rear spring or the spring will crack.

Front Springs

You can use this as a template to make springs. Simply photocopy the picture and adjust the size according to the ruler. Cut them out and trace them to your spring stock. The front spring template has a regular spring and short spring for a cut back machine.

Rear Springs

On this template are a few different styles of rear springs. There are different lengths and widths, and you can customize them further if you have to.

Contact Screws

The best material for a contact screw is silver. It has an IACS Relative conductivity rating of 106. It is the best conductor there is. Copper screws are good, their rating is 100 annealed or 85.5 hard. Brass screws are not good, although you see a lot of machines sold with brass screws. The IACS rating for brass is 28, one of the worst ratings there is. It's a wonder we never see aluminum being used for contact screws, with a rating of 59 it would be better than brass but not as good as copper or silver. Brass should be replaced with a silver or copper screw, preferably silver. Silver screws are easy to get, most every Tattoo supplier sells them. Copper you may have to make yourself. Just purchase copper rod in the right diameter and thread it. American contact screws are usually 6-32, so you will need #6 rod or .138 diameter. You don't have to keep your 6-32 contact screw, you can make it 8-32 by drilling the hole bigger and retapping it. A thicker contact screw will actually make the Machine run smoother. You can also drill and tap the front binding post of a metric Machine so you can use standard screws.

The tip of the screw that makes contact with the spring will develop a carbon build up. Every so often you should use a small file and clean up the tip of the screw. After doing this you may have to readjust the Contact Screw.

Coils and Capacitors

Coils

If you compare an 8 wrap Coil to a 10 wrap Coil, the 8 wrap would be stronger at a lower power setting compared to a 10 wrap at the same setting. The 10 wrap would need more power to pull at the same strength as an 8 wrap. The 10 wrap, however, has more potential. Meaning that it can handle more power than the 8 wrap, and can work harder with out getting hot. I read in a book about Tattoo Machines that larger coils will run hotter than smaller ones, this is not right. The basic reason why coils get hot is because of the electricity running thru them. The more electricity, the hotter they will get, electricity generates heat. Therefore, if a larger coil can handle more electricity, common sense tells us that it will not run hotter than a smaller coil. This is not to say that larger coils can not get hot, they can, and sometimes will. But it will take a lot more power to make them get that way. Try doing this to show you what I mean, don't worry you won't ruin your machine. If you're real anal about your machines then just don't do it, simple as that. Take a good running machine that does not run hot, put a pencil between the front coil and the arm bar, or just use your thumb to hold the arm bar so it keeps contact with the contact screw. Run the machine, the pencil or your thumb will stop it from running. In less than a minute the

coils will start to get hot. This is from the electricity going thru them. The longer the coils stay "on" the hotter they will run. Hot coils can mean other things also. The coil screws and shims have to be low carbon steel. The Yoke, if the machine has one, has to be low carbon steel as well. The yoke should also be at least 3/16" thick. If you have to replace the yoke with a thicker one and find your coils don't fit, you can raise the spring higher with a spring riser.

Capacitors

Basically a capacitor stores electricity. A capacitor has two wires that connect to two metal plates inside the cylinder. These metal plates are separated by a dielectric. The dielectric can be any nonconductive material, air, paper or plastic. The capacitor can be charged up to its rated capacitance. For Tattoo Machines we use small Capacitors that are measured in microfarads. The voltage rating you see on the capacitor is how much voltage it can handle. If it is overloaded it will explode. On a Tattoo Machine the capacitor evens out the voltage by absorbing the peaks and filling in the valleys of the current. What this does is get rid of the spark between the front spring and contact screw. If your machine is sparking you need to replace the capacitor. A lot of Artists will say 47mfd for shaders and 22mfd for liners. But there's more to it than this. A traditional Liner was a cut back with 8 wrap coils, and the shader was usually a 10 wrap. I never use a Machine with 8 wrap coils and I

use a 47mfd for all my machines. But this is all a matter of preference.

Tattoo Needles

Various types of needles are used for Tattooing, there are #12 Eyeless Sharps, Entomology pins, Textured and Carbon needles. These needles also come in types of Point or Tapers. There are many different kinds but the three basic types are Standard or Sharp, Long Taper and Bullet or Blunt.

Standard Taper
Long Taper

Long Taper Needles are mostly used for Liners.

Standard Needle Long Taper Needle

Tattoo needles are soldered into different needle groupings using Lead free Solder. Lead solder is never used to make needles as Lead is poisonous and will affect the person being tattooed. The type of needle used in the grouping depends on what you're going to do with it. The two types of grouping are Round

Needle Groups and Magnum Groups. We will not be discussing Flats here, professional Tattoo Artists do not use flats. Round groupings include Liner groups and shader groups. The difference being that a liner group is usually "tightened". Which means the points of the needles are compressed together and soldered to hold them in place. They can't be compressed too much though, or they will not put ink into the skin. Lkiners are usually not more than 8 needles. Shading and Coloring Rounds, called "Loose" Rounds can have up to 100 needles! Magnums start at 5 needles and can go up to 49 needles or more. Magnums start out as a flat grouping of needles, then thin razor blade is used to weave through every other needle, leaving two rows where every other needle is either on the top row or on the bottom row. Kind of like the way a book of matches is staggered. This type of Magnum is called a 'Single Stack" Magnum. A "Double Stack" Magnum is made by stacking a 3 flat group on top of a 4 flat group; this would give you a 7-needle double stack. A 7-needle double stack is only four needles wide. Any size grouping can be made in this way, but there is always one less needle on the top stack than on the bottom. This is true with single stack magnums also, they always have an odd number of needles, as there is always one more needle on the bottom row than on the top row. When referring to a single stack magnum there is usually no need to specify "Single Stack" as they are the most common. Double stacks give nice smooth shading, but do not

pack color well. I personally don't like them, but that's my preference.

The Long Taper needles are mostly used for Outliners as you can get the grouping of needles tighter because of the Longer Taper. The Long tapers work better in the big round groups also. The Bullet Point is better for Magnum needle groups, although Some Artists prefer the Sharp point for Magnum groups, it's all a matter of preference.

The Bullet Point stretches the hole it makes wider at a shorter depth than a Standard Point. A lot of Artists find this useful when Coloring. Textured needles work very well for Coloring also. If you look at a textured needle up close you see that it is, well... textured, meaning that it has little pits on its surface. These "imperfections" work to your benefit.

Depth of "Bullet" Point

Depth of "Sharp" Point

The Sharp Point needle has to penetrate deeper in comparison to the Bullet Point.

What these little pits do is hold the ink particles as the needle penetrates the skin. On the way out the skin hugs the needles and pulls the ink particles off. This action helps put more ink into the skin than the smoother stainless needles. Carbon needles are the same thing. They are actually low carbon steel which has an imperfect surface. The problem with Carbon needles is that since they are low carbon steel, they rust. Which means they have to be made just prior to doing the tattoo. An Old school method of keeping the needles from rusting was that after they were made they were cleaned and rinsed and stuck into a jar of petroleum jelly. This would keep an airtight shield around the needles. I remember in the back room of a local shop I used to go to all the time, seeing a jar of Vaseline with needle bars sticking out of it. But that was a *long* time ago.

Entomology pins or "Bug pins" as they are called don't offer any taper choice. But they do come in different thicknesses. The three common sizes are, from bigger to smaller, 0, 00, and 000. You will hear artists refer to them as Zero, Double 0's and Triple 0's. They also come in 0000, but those are much too thin. And sizes 1, 2, 3 etc. But those are too thick for tattooing. Well, you could go up to a 1, but that's as far as I would suggest.

The single Zero pin is about equal to a #12 sharp. And the double 0 and triple 0 get thinner. The thinner needles are great for subtle gray shading. The reason being is that

because they are thinner, the holes made in the skin are closer together which gives a softer, smoother appearance. To demonstrate how thin they are a 9-needle-00 magnum grouping will fit in a standard 7-magnum tube.

I should also mention Single needles here even though they are not really used that much anymore. A single needle group is actually a three needle liner group with two needles pulled back just enough so they don't penetrate the skin. These are "Feeder Needles" in that they hold and feed the ink to the working needle.

7 Needle Magnum

5 Needle Round

3 Needle Round

Single Needle

This illustration shows the Single needle from the side to show the Feeder Needles. The 7-needle magnum is an example of a "Single Stacked" Magnum.

I also want to tell you about Round Magnums. Round Magnums aren't really round, the points of the needles are shaped like a filbert paint brush.

"Round" 7-Needle Magnum

In this picture you can see how the needles are gradually pulled back in a round magnum. These needles are real good for coloring or shading, they give a real nice feather when used for shading.

Adjusting Machines

To adjust rear spring tension on your Machine loosen the Spring Shelf Screw and swing the Armature set-up out. Don't loosen the screw too much, just enough to loosen the Arm Bar Set-up. After you swing the Arm Bar Set-up out you can tighten the screw with your fingers to snug it up a bit.

Loosen the Spring Shelf Screw and swing the Armature set-up out.

To add more tension to the rear spring, gently push the Armature bar up. To relieve tension on the rear spring push the Armature bar down, gently. Swing the Arm bar Set-up back in position and run it to see if its to your liking. Repeat these steps if the Machine needs further adjustment.

In The Craft of Tattooing I talk about tuning machines. But since that book was geared for beginners I gave very basic "text book" instruction on tuning. There' is a lot of information to absorb for an apprentice Tattoo Artist, along with the anxiety of actually doing a permanent tattoo on people. I didn't want to confuse the beginner and burden his already

heavy load with swing arc, and frame geometry, fulcrum point, angel of deflection and every thing else that makes a machine behave the way it does. But now that we know about this stuff we can make the machine behave the way *we* want it to behave. A liner's contact swing arc *should* be smaller than the arm pins swing arc. This will give a fast running machine with a greater penetration. A shader/color machine *should* have the contact swing arc more forward. Meaning it should be about equal and even greater than the arm pin's swing arc. This will make for a slower running but hard-hitting machine. I say *"should"* because these are not rules and each artist is different. A machine set up for lining can and would make a great shader, depending on the preference of the artist. The possibilities of tuning a machine are endless with adjusting swing arc and spring tension, including thickness and width of springs, contact screw material, coil size and frame material. Just like people have different personalities, so does a tattoo machine, and each machine has to be tuned according to it's individual make up, the intent of its use *and* the preference of the artist who is using it.

When you tune your machine the way you want you should not have to touch it for a long time. I work in a very busy shop and nobody I work with ever has to fuck with there machines. If you have to mess around with your machine all the time there is something wrong, unless you drop it all the time. I have a

machine I bought from someone around four or five months ago. I adjusted it to run the way I want it to and haven't touched it since. I haven't screwed around with my shader in about two years. Sure, the front spring has a nice little hole starting in it but it runs great. I don't fix what's not broken. Tattoo Machines don't have "souls", they're tools, like a wrench is to a mechanic. I'm not saying that you should not have respect for your tools or that you shouldn't take care of them. You should, but the sooner you realize that a tattoo machine is a tool, the easier it will be to tame it and make it do what *you* want it to do.

Machine Frames

We already mentioned a lot about machine frames in the Frame Geometry section. So here we will talk about Frame Materials. A Machine Frame can be made out of just about anything, Metals, Composites, Plastics, anything. How good a Machine will be made from some of these materials is another question. There were a lot of old Machines made form a stuff called Bakelite. Bakelite is a composite material that is not really used anymore. It was replaced with plastics and other types of composite. If you come across an old Bakelite Machine you could get a good price for it from a Machine collector.

What material works the best for a Machine frame is really just a matter of opinion. It's the preference of the Artist who is using it. I like Cast Iron Machines the best, but I do own brass Machines that run real good. Some will say a mixture of materials is best, like a steel Coil Shelf with a Brass side plate, it's all a matter preference. If you are using steel make sure its Low Carbon Steel, 1018 is good, it's readily available and it's as close to Iron as you can get. Stainless Steel is not very good. If you use stainless steel for a machine you need a yoke. Stainless steel is non magnetic. If it is it's not good quality stainless. The alloys mixed with Iron to make steel affect its magnetic properties.

Steel is according to AISI designations. (AISI- American Iron and Steel Institute.) If you look at the Designation Number, the first two numbers are what type of steel it is. For example 10xx would be Plain Carbon Steel. The 10 designates Plain Carbon Steel with a maximum carbon content of 1 percent. 15xx is also Plain Carbon Steel but the Carbon content is between 1.00 and 1.65 percent. For Tattoo Machines we want the 10xx designation. The second pair of numbers tell us what the Carbon Content is. For 1018 Steel the Carbon content is 0.18 percent. Carbon content can be lower than that but 1018 is the most common.

I heard that a Machine Builder had once said that Cast frames aren't as good as machined frames because of the tiny air pockets that are inherent in casting metals. He said that it slows down the current passing through the frame as it does not have a steady path. That might be true, but we would need NASA quality equipment to test it out. And if we were sending Astronauts to Mars and the men's lives depended on the structural quality of the metal, it would definitely raise some concern. But the fact is our Astronauts lives do not depend on it, we are only doing tattoos. And as important as that is, I don't think it matters if the electric current has to take a fraction of a millisecond to go around a microscopic air bubble. The point I'm trying to make is that even though there is a science

behind a Tattoo Machine, it's not Rocket Science. Kids are building Tattoo Machines in their garage, and most of them are building damn good ones at that! There is no need to confuse or make the "science" more complicated than it has to be.

Conductivity is measured by the International Annealed Copper Standard. The conductivity of the annealed copper is defined to be 100% IACS at 20°C. The conductivity of all metals are compared back to this conductivity of annealed copper. This Standard was adopted in 1913 so copper products available today have IACS conductivity value greater than 100% because processing techniques have improved and more impurities can now be removed from the metal. The following is a comparison of various metals and their conductivity rating. Some of the metals listed aren't used to make tattoo machines, they are listed just for comparison.

Metal	Relative Conductivity
Aluminum (pure)	59
Aluminum (alloys):	
Soft	45
Annealed	50
Heat-treated	30-45
Brass	28
Copper:	
Hard drawn	89.5
Annealed	100
Gold	65
Iron:	
Pure	17.7
Cast	2-12
Wrought	11.4
Lead	7
Molybdenum	33.2
Nickel	12-16
Nickel silver (18%)	5.3
Phosphor bronze	36
Platinum	15
Silver	106
Steel	3-15
Tin	13
Titanium	5
Tungsten	28.9
Zinc	28.2

This information was determined by the International Electro-Technical Commission in 1913 and has been in use ever since. According to this chart Aluminum is a better conductor than Cast Iron and Brass! The problem with aluminum is that it is too light, most Artists prefer a heavier Machine. In reality a Tattoo Machine does not have to be conductive. Some old Machines were made from Bakelite. As long as the spring makes a connection with one of the clip cord terminals the Machine will work.

Boiling Down Black

Before Talens came around we had to boil our Pelican- Yellow Label Black down to make it darker. You can also do this with Talens to make it even darker.

Here's how it's done:

Equipment needed-
Double Boiler
Funnel
Ice cream sticks.

Directions-
1) Fill the bottom of the Double boiler with water and put the top part on.
2) Pour your Pelikan Ink in the top part of the Boiler.
3) Use an Ice cream stick as a dipstick to measure how much ink is in the pot. Wipe the excess ink of the stick with a paper towel. Wipe down from the clean part of the stick. This is so the ink doesn't soak into the wood and make the mark higher.
4) Simmer the ink uncovered, so it steams. Don't bring it to a boil, just let it simmer. I know it's called "Boiling off" but we don't really boil it. Measure the amount of ink with an Ice cream stick every so often until you boil off the amount you want. I usually boil it down to about half way.

5) When you boiled off the amount you want let it cool down and funnel it back into the bottle. Label the bottle so you know it contains Boiled down ink.

Shading

Gray Wash

Water is used to tone down the black ink when doing Gray wash Shading. Contrary to what you may have heard, ordinary tap water is perfectly safe to use in the skin. Some people say that you have to use distilled water, this is not true. Many of the people who say this contradict themselves by using tap water to rinse their needles between colors, and also use tap water to dilute the soap mixture in their spray bottles.

The FDA does not regulate water. Even if it did, distilled water would not be regulated, as it is not sold for human consumption, it's for use in irons that you use to iron your clothes, and automotive batteries. It is distilled to remove trace minerals, making it soft water. Sterilizers should also be filled with distilled water as the minerals in tap water will stain the inside of the unit and it's a real pain in the ass to clean.

Bacteria are found in all water; tap water, distilled water, even mineral water that you purchase to drink. Distilling is not the same as sterilizing. If you want to use sterilized water you would have to sterilize it in single use containers, or boil it for 15 minutes before you use it on a customer. Both processes are not very feasible in a busy Tattoo Studio. If you insist on using distilled water, that's fine, you

can use it. I just don't like people who come off like their some kind of hero because of it, and then preach about it like it's a holy act. The fact of the matter is that Tap water, distilled water or bottled drinking water can all be used in Tattooing. Basically, if the water is safe to drink, it's safe to tattoo.

Sumi

Sumi-e is a Black Ink that is used for Chinese Brush Painting. When it is tattooed in the skin it lightens to a silvery tone. Sumi is made from the soot of rapeseed oil or pine resin. The soot is mixed with a binder and formed into decorative sticks that are works of art in themselves. You can grind your own ink if you like or you can buy it pre made in a bottle. Make sure you are buying Sumi-e Ink made for Sumi-e painting as real Sumi ink is the only ink that will give you the light silvery tone.

Sumi ink does not heal solid black. It lightens very much by the time it heals. You can water it down but not more than 25% water, otherwise it will heal too light.

To grind your own you will need an ink grinding stone and sumi-e ink sticks. Place a few drops of water on the shallow end of the stone, then, holing the stick upright,move in a circular motion. Push the ink that is produced into the deep end of the stone. Repeat the process as needed. Store the ink in a bottle

marked "Sumi". After you're done rinse the stone really good to remove all traces of ink as any residue will completely fuck up the stone.

Mixing Ink

Equipment needed:
1. Blender with a Glass Container (Glass is easier to clean.)
2. Quart size jars
3. 4 or 8 oz inkbottles
4. Dry Pigment
5. Vodka, Ethyl alcohol, Grain alcohol, Witch Hazel or Listerine
6. Glycerin
7. Propylene Glycol (KY Jelly)
8. Big Metal mixing spoon
9. Glass Measuring cups
10. A funnel
11. Sterilized 3/8" stainless steel bolts

Directions:
It is advisable to make ink in an area that doesn't matter if you get ink all over the place, like a garage or basement. Build or buy a workbench that will be used exclusively for making ink. It is also a good idea to wear rubber gloves when you mix ink.

Fill a quart jar about two inches from the top with the Alcohol, Witch Hazel or Listerine. (Or a mixture of all three) Add about a half-ounce of glycerin and a half-ounce of propylene glycol and mix it up. This is your "Vehicle Solution"

Put about a cup of Dry Pigment in a clean blender and pour about two cups of your Vehicle solution to the mixture. Put the lid on and blend it up for a few seconds. Check the consistency to see if it's where you want it. Consistency can be anywhere from a loose paste to the consistency of ketchup. Add more Vehicle solution or powdered pigment to adjust the consistency to your liking.

When you have found the right consistency, run the ink mixture in the blender for 15 to 30 minutes. Some people even blend it for as long as an hour.

When your done blending pour it in a jar or bottle and label it with the color and date. Drop a sterilized bolt in an empty ink bottle and fill it up leaving about an inch of space from the top. The nut helps when you shake your ink, just like a marble in a can of spray paint. Don't use a marble in your ink, when you turn the bottle upside down to pour the ink, the marble will act as a stopper and clog the bottle. The nut, with its irregular shape and a hole in the middle will let the ink pass.

Clean everything real well to get the color out. You might even want to clean the pigment outside with the garden hose. Don't worry pigments are not dangerous to the environment, they are made from minerals or plant matter. If you do it outside you should choose a corner of the yard where nobody

goes. This way no one can step in it and trek pigment all over the house.

Tattoo Pigments

Tattoo ink consists of pigment that is suspended in a liquid agent. Among the safest and most common ingredients used to make the suspension agent are:

Distilled water
Ethyl alcohol (ethanol)
Grain alcohol
Listerine
Witch hazel

Propylene glycol and/or Glycerin are usually added to the suspension.

The Pigments used are "Lake Colors". The word "Lake" differentiates a pigment from a dye.

Black
Iron Oxide
Carbon
Logwood

Brown
Ochre - Ochre is composed of iron oxides mixed with clay. Raw ochre is yellowish. When dehydrated ochre changes to a reddish color.

Red
Cinnabar
Cadmium Red

Iron Oxide,
Napthol-AS pigment

Orange
Disazodiarylide
Disazopyrazolone
Cadmium seleno-sulfide

Yellow
Cadmium Yellow
OchresCurcuma
YellowChrome Yellow
Disazodiarylide

Green
Chromium Oxide:
 (Casalis Green or Anadomis GreenMalachite)
Ferrocyanides and Ferricyanides
Lead chromate
Monoazo pigment
Cu/Al phthalocyanine
Cu phthalocyanine

Blue
Azure Blue
Cobalt Blue
Cu-phthalocyanine

Violet
Manganese Violet
 (manganese ammonium pyrophosphate)
Aluminum salts
Quinacridone
Dioxazine/carbazole

White
Lead White (Lead Carbonate)
Titanium dioxide
Barium Sulfate
Zinc Oxide

Spit Shading Flash

Spit shading is actually dry brushing. You moisten the brush with spit and use it to watercolor the flash. You will hear about all kinds of complicated techniques and you can buy real expensive painting equipment. But the fact is Spit shading is very simple and was done with the cheapest materials. Like a child's set of cheap watercolor and the cheap little brushes that came with it. I remember when I first started Tattooing I used to visit a Small Tattoo Shop that was operated by the solely by the owner, nobody else worked there. I went in one day to say hello and there he was coloring a sheet of flash that he drew himself with a ballpoint pen, on a piece of illustration board. He was coloring the designs with a cheap set of watercolor cakes, the ones that come in the plastic case, and each cake is about the size of a quarter. I can't remember what kind of brush he was using, I was too awed by how amazing the coloring was coming out. Although he wasn't using spit, he had a cup of water set up. It would be fun to explore spit shading with these "traditional materials", but if you want to explore Spit shading as a fine art, especially if you want to sell your finished work, then you will want to get good quality, modern materials. Dr. Ph Martin's liquid watercolor will definitely hold up a lot better than a cheapo set of watercolors. And some good watercolor brushes will make life

easier also. You will want to use some good watercolor paper, 140 lb. cold press. It's kind of expensive but it will give you the best results.

Spit Shading Black
Use Black tattoo ink, Pelikan work's the best. With the Pelikan you don't have to wet the brush with water first, just dip it in the ink dry it off a little and apply the ink to the drawing where you want it. Dry the brush off really good then put it in your mouth and moisten it with spit. Don't that ink taste great! After a few seconds use the spit brush to feather the ink out, drag the brush back and forth, zig-zaging it. That's all there is to it.

Dry Cake Method
You can use the above spit method to moisten the brush or you can dip the brush in water and then dry it slightly on a paper towel. Drag it in the color you want, lifting the paint onto the brush. Now just apply the paint to the drawing, feathering the paint as you go. When you find you cant feather any more, such the brush again or wet and dry the brush with water, then you will be able to "drag" the feathering out a little more.

Liquid Color Method
Use the same technique that is described for the Black, except substitute the black ink for the color you want to use.

When you are done coloring the flash you should go over the outline again with a fine point marker or 5 or 7 mil tech pen.

Experiment with different techniques. You will find that if you lift the brush then put it down again it will make a mark in the painting. This can either fuck things up or you can use this for effect. Water coloring is usually done light to dark, but this isn't a rule. You'll have to experiment to find what works for you and what doesn't.

Other "Secrets"

It's amazing what some Tattoo Artists consider trade secrets. You could talk to one who might let you look through a supply catalog but when you ask a question about how to do something he will get defensive. Another would tell you everything about how to tattoo but not tell you where he buys his gloves!

The following are a few things that wouldn't really fit anywhere else. Some of them might be minor information but they will still help you to know about them.

Tattooing

When doing a black and gray tattoo you do not have to outline first. You can attack it with your shader, then follow up with the liner to sharpen any edges that need to have an edge. You can even blood line or gray line some or all of the tattoo, then start shading. To know when to use this technique will come with experience. You can also fill in a tattoo with your liner, you don't have to color with a magnum. A small kanji can be done completely from start to finish with a 5 liner. I once worked with someone who insisted I was doing the tattoo wrong because I didn't fill in kanji and smaller tribals with my magnum! Sometimes a round will pack black more solid than a magnum. AT TIMES IT, oops, sorry, I

81

hit the cap locks button by mistake. What was I saying? Oh, I remember- at times it would be necessary to set up your shader with a larger round to do some tribal pieces. I would consider any needle, 7 round or more to be called a "Round" instead of a "Liner". This would remove the tendency of only using it to line with.

If you want to be a good Tattoo Artist you have to find what your best at and specialize in that. If you look at all the well-known Tattoo Artists you will notice that they specialize in a certain style. Very few of them do everything. It's like that in all trades, there are diesel mechanics, marine mechanics, auto mechanics. There are even mechanics that specialize in foreign or domestic and transmission specialists. Doctors specialize in certain fields of medicine. A heart surgeon will not remove an appendix. The same goes for tattooing. Of course there are "general practice" tattoos we have to do to pay the bills. But you will find that there is something that you are good at and people will come and ask you for that particular thing. You specialty may even come as a surprise to you, but you will find that you excel in some style of tattooing.

Stencil Applying

For applying stencils you can use soap, any kind of soap. Spray the soap right from your spray bottle lightly onto the skin. Gently rub it around the area with your glove on and let it

dry for a few seconds till its tacky. Then apply your stencil as you normally would. Soap actually works better than a Speed Stick. K-Y or any other kind of personal lubricant works real good also, use it the same as you would use the soap. The trick to this is a little goes a long way.

Soaps

While we're talking about soaps you should also know that you don't have to use Green soap to do a Tattoo. A lot of Artists use the Dr Bronner's Magic Soap. The liquid soap comes in all kinds of fragrances, Almond, Lavender, Peppermint, Eucalyptus, Tea-tree and Unscented Baby Mild.

You can also use Baby bath soap or Baby wash soap found in any grocery store. Use it like just like green soap, put a small amount in your spray bottle and fill it up with water. If it suds up spray a little alcohol in there to kill the suds, then fill it up the rest of the way.

Water Dipping Rinse

While your working on a big piece you will find that you pick up a lot of blood and body fluid on your needles. When you dip into the color or black you leave some of this in the cap. After a while the pigment in the cap will thicken and become hard to work into the

skin. If you rinse the needles in a cup of clean water BEFORE you dip for more ink you will clean the body fluids from the needles. If you ever watched an Artist at a convention doing Tribal and has a dip cup of water, this is what he is doing. I've heard people assume that he is dipping into the cup *after* he picks up the ink, like he was doing a gray wash. Watch closely and you will see just the opposite. I have actually worked with an Artist who assumed this and dip for a tribal piece as if they were doing gray wash. I don't say anything to them, it's not my place to tell a "professional" how to do things, but it is funny seeing the customers come back, not just for touch ups but to have the whole thing done over because it healed too light.

Spitting Machines

If your Liner Machine spits and you've tried everything and it still spits, you might need new tube tips. See if there's a groove in the tip. If there is, break out a new tube. If you're working in a real busy shop like we do here in NY, you don't want to waste time changing tubes. And your boss doesn't want you to either! (And you're at work to make you and your boss happy, not the idiots on the Internet chat room.) So in this case, loosen up the tube vise and give your tube a twist so that that the opening on the tube faces to the right. (I'm a lefty, so I face mine to the left.) This will bring the needles out of the groove that is worn in

the tube tip. When your done separate the tube from the rest so you can fix it. And check your other tubes when you get a chance, if one is grooved, others will be also. This trick only works with a liner or rounds.

Frame Hardware

By frame hardware I mean screws and washers. Screws and washers used on the binding posts or the spring can be made of any metal, brass, copper or steel. But for coils they have to be Low carbon Steel. Coils are electromagnets, meaning you need a magnetic material as a core or they won't work. The space in the core that was drilled and tapped has to be filled with a magnetic material. If their not, the coils will not only get hot, but will not work to there full potential. Low Carbon Steel shims should be used on the coils also. I remember a while back I was working with an Artist who told me he has a lot of secrets on his Machine that he won't tell me about. Not that I asked him, he just came out and made the announcement. Then he tried to impress me with an original Jonsey Machine that he had "refurbished". On his "refurbished" machine he decided to replace the old coil screws with brass ones! Like I said before, it's not my place to tell a "professional" how to do things. Oh, and by the way, he is one the people who are angry that I write these books on tattooing.

Tube Bath

When you break down your machine after a tattoo soak your tubes in Murphy's Oil Soap. This will loosen any ink that's remains in the tube after rinsing. When your ready to clean the tubes fill an ultrasonic with water and add some oil soap, drop the tubes in and let the ultrasonic rip for little while. Rinse the tubes, bag'em and sterilize them in the autoclave. Never soak your tubes in bleach. Bleach will corrode stainless steel. And never reuse needles, put them in sharps container when your done and dispose of that when it's full according to your local Board of Health regulations.

Beveled Tube Tip

If you bevel the tips of your tubes it will be easier to see the needles while you are working. You can use a file or medium sharpening stone to cut the bevel.

Changing Colors

When rinsing between colors I like to use a small ultrasonic cleaner. The on I use is sold for cleaning Tech Pens, it's small one with a push button located on top. I fill the reservoir with water, then before a tattoo, I fill a 7 oz. disposable plastic cup with water and place it in the reservoir. I then spray some soap

mixture in the cup from my spray bottle. Between colors I turn the ultrasonic on and run my needles in the cup of soapy water, this cleans all the ink from the tube in seconds. I then rinse the soap away and I'm ready for my next color.

If you don't want to use an ultrasonic, just rinse the tube tips under some running water. If you get a color that just doesn't seem to come out spray some soap from your soap bottle into the tube tip with the machine running, then rinse the soap away. This should clean all the old color away.

Lining with a Shader Tube

This is an Old School trick that nobody really does anymore, but I thought I should tell you about it. You can run a liner in a square shader tube. All you have to do is angle the tube so the needles sit in the corner, just like in the illustration. This will work if you use large rounds to color with. You can still use your Shading tubes even though you're using a round.

Rubber Bands

You don't have to use the old #12 rubber bands on your machines. You can also use elastic hair bands. They last a lot longer than rubber bands do and having them in your draw comes in handy when a girl has to put up her hair so you can tattoo her neck or shoulder.

Back of the Neck Tattooing

When you tattoo the back of a girls neck they always have shorter hairs that can't be tied up in the hair band. These hairs are a real pain in the ass. To get them out of the way apply a little A&D Ointment or Petroleum Jelly to the root area problem hairs and push them out of the way. They will stay right where you put them. Don't forget to tell the girl you did this just in case she wants to go home and wash it out of her hair.

Soldering

When soldering electrical connections always use Silver Bearing Solder. Silver Bearing Solder is the most conductive solder, there will be a difference in the way your machine runs if you don't use Silver Solder.

You should also use this solder for Needles, NEVER use lead solder for needles. Lead is

poisonous and it will affect the person you are tattooing.

Conversion Charts

Fraction/Decimal

Fraction	Decimal Value
1/64	0.015625
1/32	0.03125
1/16	0.0625
1/8	0.125
3/16	0.1875
1/4	0.25
5/16	0.3125
3/8	0.375
7/16	0.4375
1/2	0.5
9/16	0.5625
5/8	0.625
3/4	0.75
7/8	0.875

Gauge/Decimal

Gauge No.	American Wire Gauge (AWG) and Brown and Sharp
1	0.28930"
2	0.25763"
3	0.22942"
4	0.20431"
5	0.18194"
6	0.16202"
7	0.14429"
8	0.12849"
9	0.11442"
10	0.10190"
11	0.09074"
12	0.08081"
13	0.07196"
14	0.06408"
15	0.05707"
16	0.05082"
17	0.04526"
18	0.04030"
19	0.03589"
20	0.03196"
21	0.02846"
22	0.02535"
23	0.02257"
24	0.02010"
25	0.01790"
26	0.01594"
27	0.01420"
28	0.01264"
29	0.01126"
30	0.01003"

AWG/Inch/MM

AWG Number	Inch	mm
6/0 = 000000	0.580	14.73
5/0 = 00000	0.517	13.12
4/0 = 0000	0.460	11.7
3/0 = 000	0.410	10.4
2/0 = 00	0.365	9.26
1/0 = 0	0.325	8.25
1	0.289	7.35
2	0.258	6.54
3	0.229	5.83
4	0.204	5.19
5	0.182	4.62
6	0.162	4.11
7	0.144	3.66
8	0.128	3.26
9	0.114	2.91
10	0.102	2.59
11	0.0907	2.30
12	0.0808	2.05
13	0.0720	1.83
14	0.0641	1.63
15	0.0571	1.45
16	0.0508	1.29
17	0.0453	1.15
18	0.0403	1.02
19	0.0359	0.912
20	0.0320	0.812
21	0.0285	0.723
22	0.0253	0.644
23	0.0226	0.573
24	0.0201	0.511
25	0.0179	0.455
26	0.0159	0.405
27	0.0142	0.361
28	0.0126	0.321
29	0.0113	0.286
30	0.0100	0.255

Inch/CM-CM/Inch

Inches	cm	cm	Inches
0.01	0.025	0.01	0.004
0.1	0.254	0.1	0.039
0.2	0.508	0.2	0.079
0.3	0.762	0.3	0.118
0.4	1.016	0.4	0.157
0.5	1.270	0.5	0.197
0.6	1.524	0.6	0.236
0.7	1.778	0.7	0.276
0.8	2.032	0.8	0.315
0.9	2.286	0.9	0.354
1	2.54	1	0.39
2	5.08	2	0.79
3	7.62	3	1.18
4	10.16	4	1.57
5	12.70	5	1.97
6	15.24	6	2.36
7	17.78	7	2.76
8	20.32	8	3.15
9	22.86	9	3.54
10	25.4	10	3.94
20	50.8	20	7.87
30	76.2	30	11.81
40	101.6	40	15.75
50	127.0	50	19.69
60	152.4	60	23.62
70	177.8	70	27.56
80	203.2	80	31.50
90	228.6	90	35.43
100	254	100	39
200	508	200	79
500	1,270	500	197
1,000	2,540	1,000	393.7
2,000	5,080	2,000	787.4
5,000	12,700	5,000	1968.5

Tap Drill Chart

Imperial Tap Drill Chart

Machine Screw Size		Number of Threads Per Inch	Minor Dia.	Tap Drills				Clearance Hole Drills All Materials			
				Aluminum, Brass & Plastics 75% Thread		Stainless Steel, Steels & Iron 50% Thread		Close Fit		Free Fit	
No. or Dia.	Major Dia.			Drill Size	Decimal Equiv.	Drill Size	Decimal Equiv.	Drill Size	Decimal Equiv.	Drill Size	Decimal Equiv.
0	.0600	80	.0447	3/64	.0469	55	.0520	52	.0635	50	.0700
1	.0730	64	.0538	53	.0595	1/16	.0625	48	.0760	46	.0810
		72	.0560	53	.0595	52	.0635				
2	.0860	56	.0641	50	.0700	49	.0730	43	.0890	41	.0960
		64	.0668	50	.0700	48	.0760				
3	.0990	48	.0734	47	.0785	44	.0860	37	.1040	35	.1100
		56	.0771	45	.0820	43	.0890				
4	.1120	40	.0813	43	.0890	41	.0960	32	.1160	30	.1285
		48	.0864	42	.0935	40	.0980				
5	.1250	40	.0943	38	.1015	7/64	.1094	30	.1285	29	.1360
		44	.0971	37	.1040	35	.1100				
6	.1380	32	.0997	36	.1065	32	.1160	27	.1440	25	.1495
		40	.1073	33	.1130	31	.1200				
8	.1640	32	.1257	29	.1360	27	.1440	18	.1695	16	.1770
		36	.1299	29	.1360	26	.1470				
10	.1900	24	.1389	25	.1495	20	.1610	9	.1960	7	.2010
		32	.1517	21	.1590	18	.1695				
12	.2160	24	.1649	16	.1770	12	.1890	2	.2210	1	.2280
		28	.1722	14	.1820	10	.1935				
		32	.1777	13	.1850	9	.1960				
1/4	.2500	20	.1887	7	.2010	7/32	.2188	F	.2570	H	.2660
		28	.2062	3	.2130	1	.2280				
		32	.2117	7/32	.2188	1	.2280				

Recommended Reading

Tattoo Machine: Set up, Tuning, and Maintenance.
by Joey Desormeaux, www.infiniteirons.com
Desormeaux knows more about tattoo machines than Clausewitz knows about war. Highly recommended!

Zen Guitar
by Philip Toshio Sudo
I was reading this book one day when someone said, "I didn't know you played guitar." I replied, "I don't."

Zen 24/7: All Zen, All the Time
by Philip T. Sudo

Zen in the Art of Archery
by Eugene Herrigel

Poker, Gaming, and Life
by David Sklansky

The Hero With a Thousand Faces
by Joseph Campbell
In this book you will learn about the Hero's Journey. You will be taking the same Journey in your Tattooing career.

Words of wisdom

"Zen teaches us that our approach to today determines our whole approach to life."
Philip Toshio Sudo

"Maybe all one can do is hope to end up with the right regrets."
Arthur Miller

"Sometimes the heart sees what is invisible to the eye."
Jackson Brown, Jr

"God is an American"
David Bowie

"You have enemies? Good. That means you've stood up for something, sometime in your life."
Winston Churchill

"Give me six hours to chop down a tree and I will spend the first four sharpening the axe."
Abraham Lincoln

"We cannot hold a torch to light another's path without brightening our own."
Ben Sweetland

"To repeat what others have said, requires education, to challenge it, requires brains."
Mary Pettibone Poole

Index

Adjusting Machines, 53
alteration, 33
Angle of Deflection, 27
Armature Pin, 16, 17, 20
Armature set-up, 16, 53
black and gray, 81
blood line, 81
Bug pins, 50
capacitor, 44
Carbon needles, 47
Coil Shelf, 27
coils, 21, 43, 44
 hot, 43
Conductivity, 59
Cut Back Frame, 29
Cut Back Machine, 17, 19
electricity, 44
Frame Geometry, 13, 16, 19, 57
 long, 14, 19, 29
 short, 14
Frame Materials, 57
Front Binding post, 19
front spring, 39

Front Springs, 35
fulcrum, 16, 23
fulcrum point, 23
gray line, 81
Gray wash, 65
Hot coils, 44
IACS, 59
ink, 65, 66, 69
International Annealed Copper Standard, 59
Long Frame, 29
Long Frame Geometry, 19
Magnums, 48
needles, 47
Pelican, 63
pigment, 73
Pigment, 70
Point Gap, 16
Propylene Glycol, 69
rear spring, 31
rear springs, 39
Round Magnums, 52
Short Frame, 14
Soap, 83
solder, 47, 89
Spit shading, 77
Spring gap, 16, 17, 23, 24

Spring Gap, 16, 17, 19, 20, 23, 24, 25, 30
spring riser, 37, 44
Spring shelf, 16, 32
Spring Shelf, 27
spring tension, 32, 53
Spring Tension, 13
Springs, 31
Sumi, 66
Swing Arc, 23, 25, 30
Throw, 17, 20, 23, 24, 30
tuning machines, 54
ultrasonic cleaner, 87
Vehicle Solution, 69
water, 65, 84
watercolor, 77

CPSIA information can be obtained
at www.ICGtesting.com
Printed in the USA
BVHW020030061222
653480BV00008B/442